I0396273

If found please return to

Name

Contact

Designed by Nikky Starrett
www.nikky.ca

www.ingramcontent.com/pod-product-compliance
Lightning Source LLC
Chambersburg PA
CBHW070429180526
45158CB00017B/946